i dream of the sea
a tranquil journey

written by Miki Klocke and Mary Ogle
photography by Miki Klocke
illustrations by Mary Ogle

Copyright © 2016 by Miki Klocke and Mary Ogle
All rights reserved. This book or any portion thereof may not be reproduced or used in any manner whatsoever without the express written permission of Miki Klocke and Mary Ogle except for the use of brief quotations in a book review.

Printed in the United States of America

First Printing, 2016

ISBN 978-1535205191

Miki Klocke and Mary Ogle
mikiandmary@wordandpicturebook.com
wordandpicturebook.com

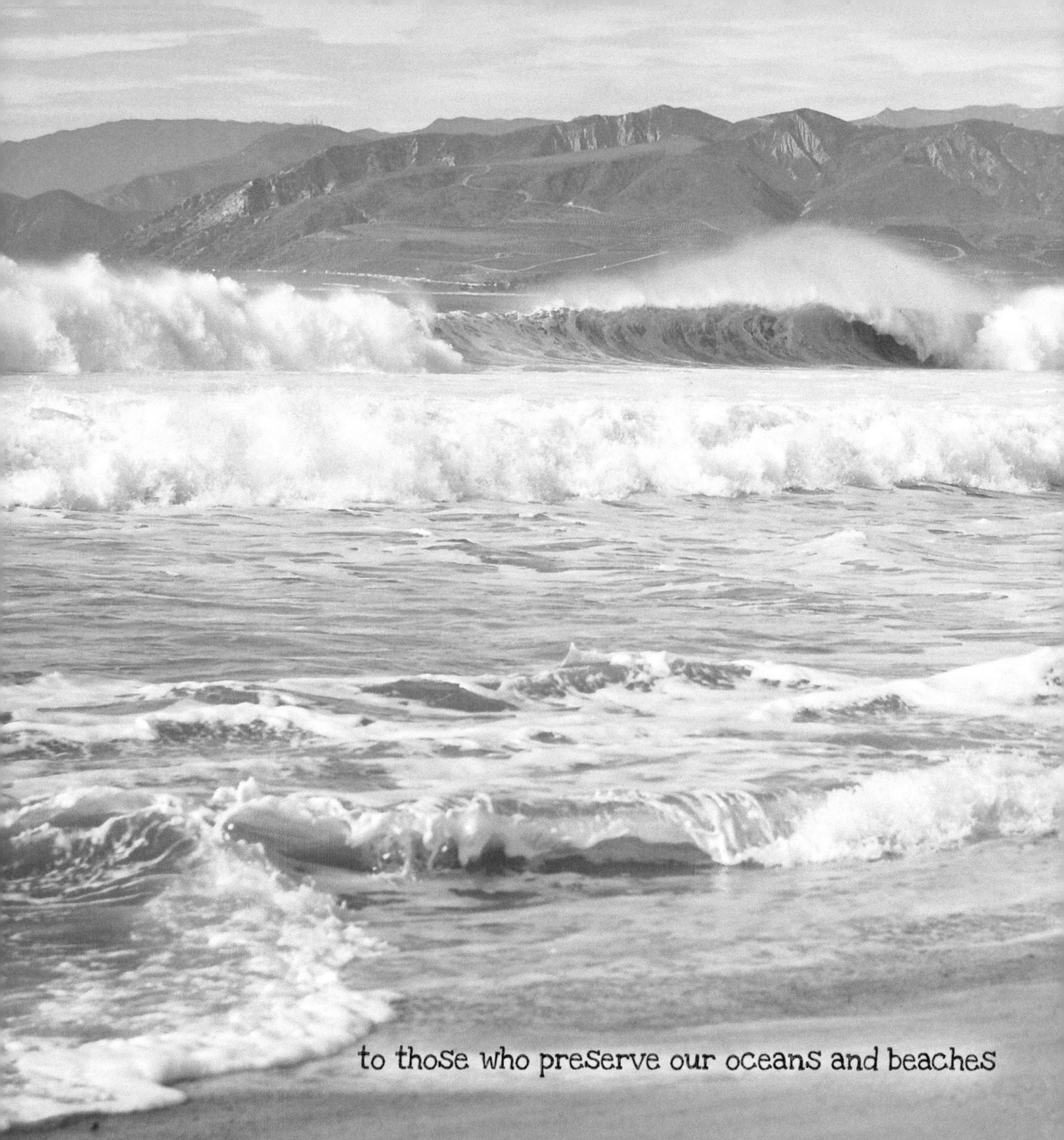
to those who preserve our oceans and beaches

more books by Miki Klocke and Mary Ogle

Orangeroof Zoo:
A Coloring Book for Adults

Written and Illustrated
by Mary Ogle, Colored by You

available on Amazon

coming soon:

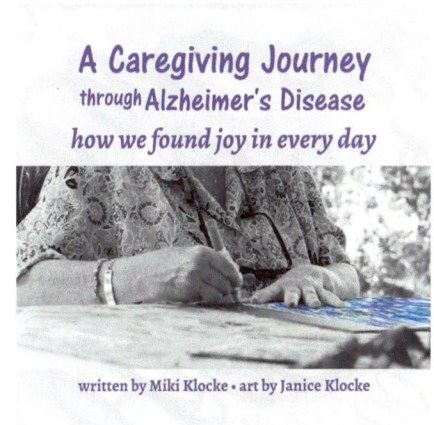

A Caregiving Journey
through Alzheimer's Disease
Written by Miki Klocke
Art by Janice Klocke

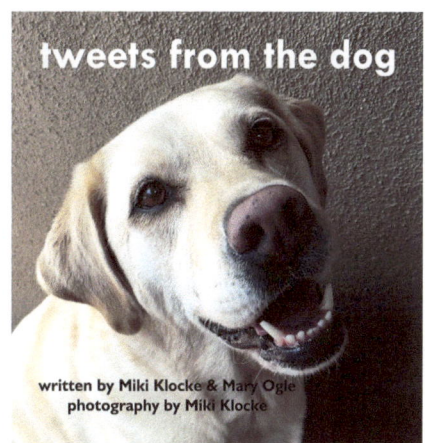

tweets from the dog

Written by Miki Klocke and Mary Ogle
Photography by Miki Klocke

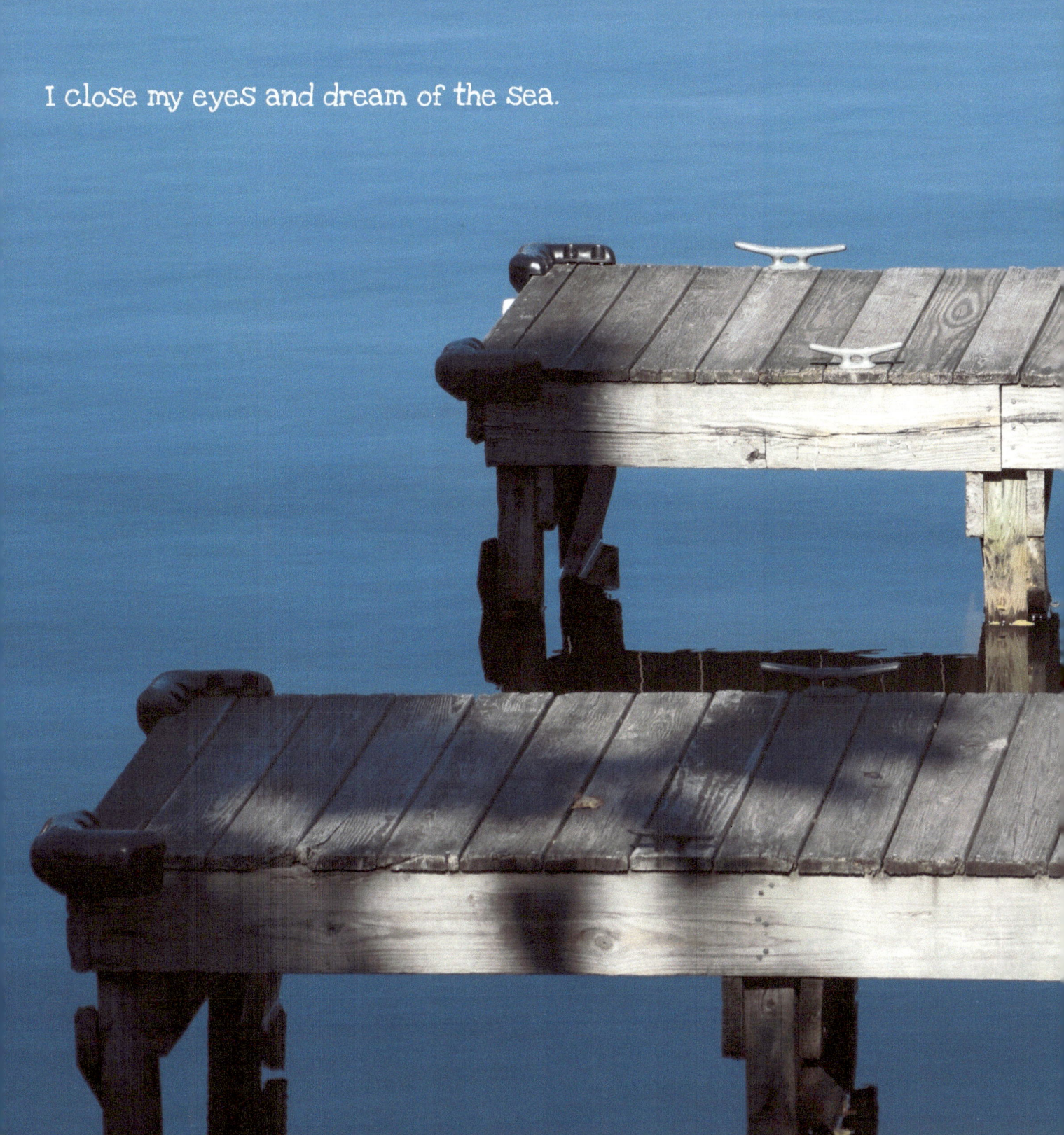
I close my eyes and dream of the sea.

My feet find wind-swept sand.

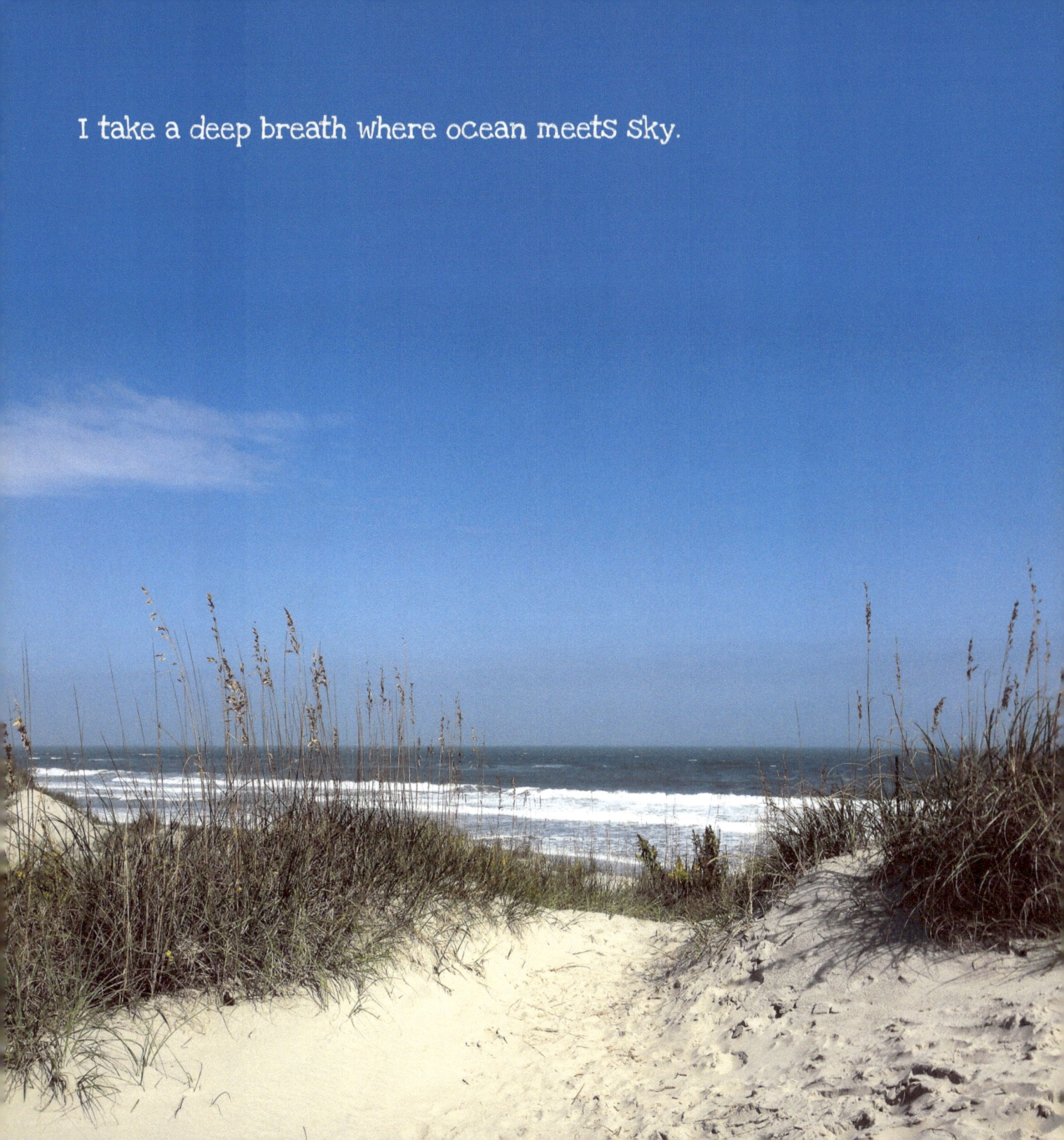
I take a deep breath where ocean meets sky.

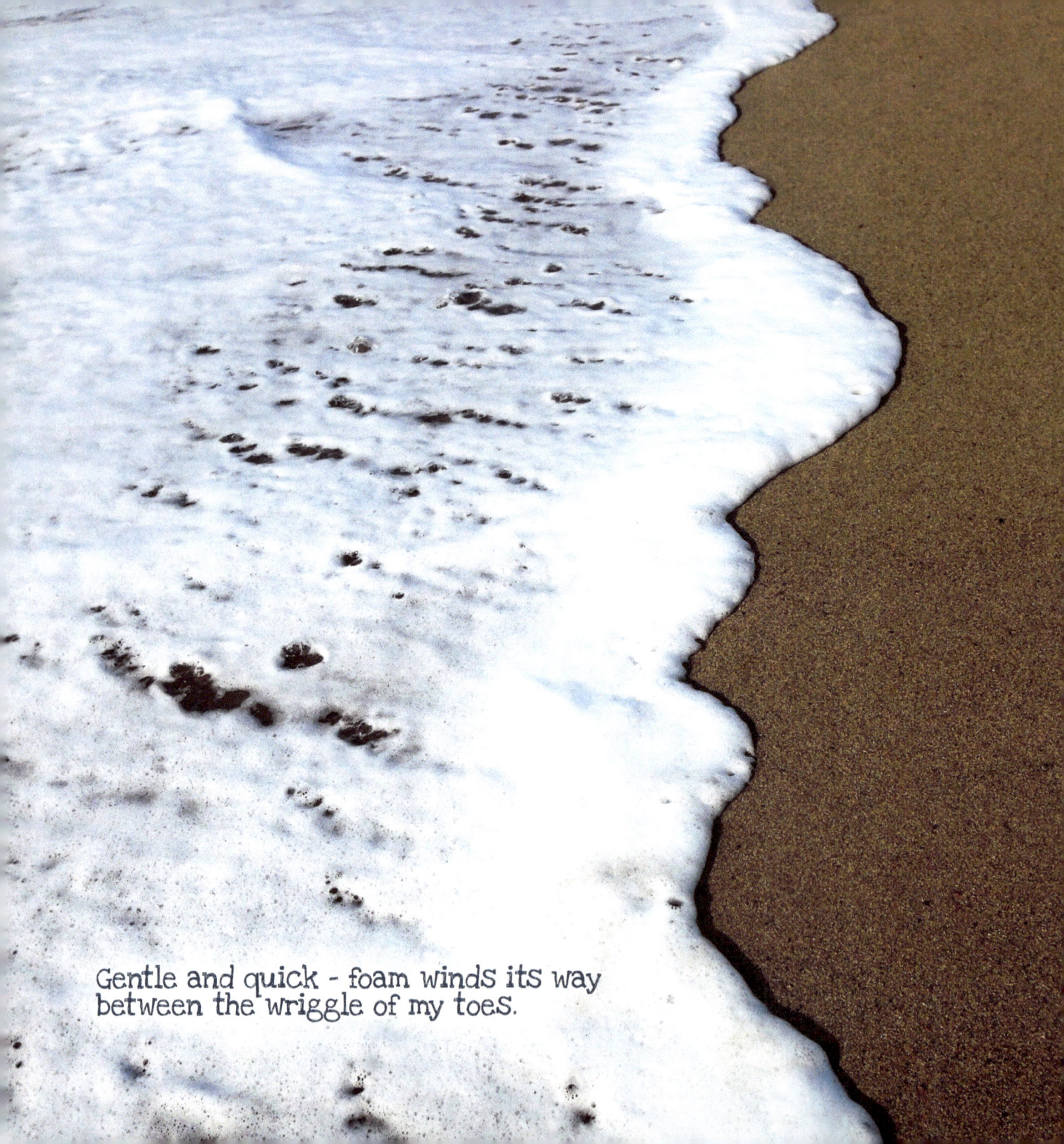
Gentle and quick - foam winds its way between the wriggle of my toes.

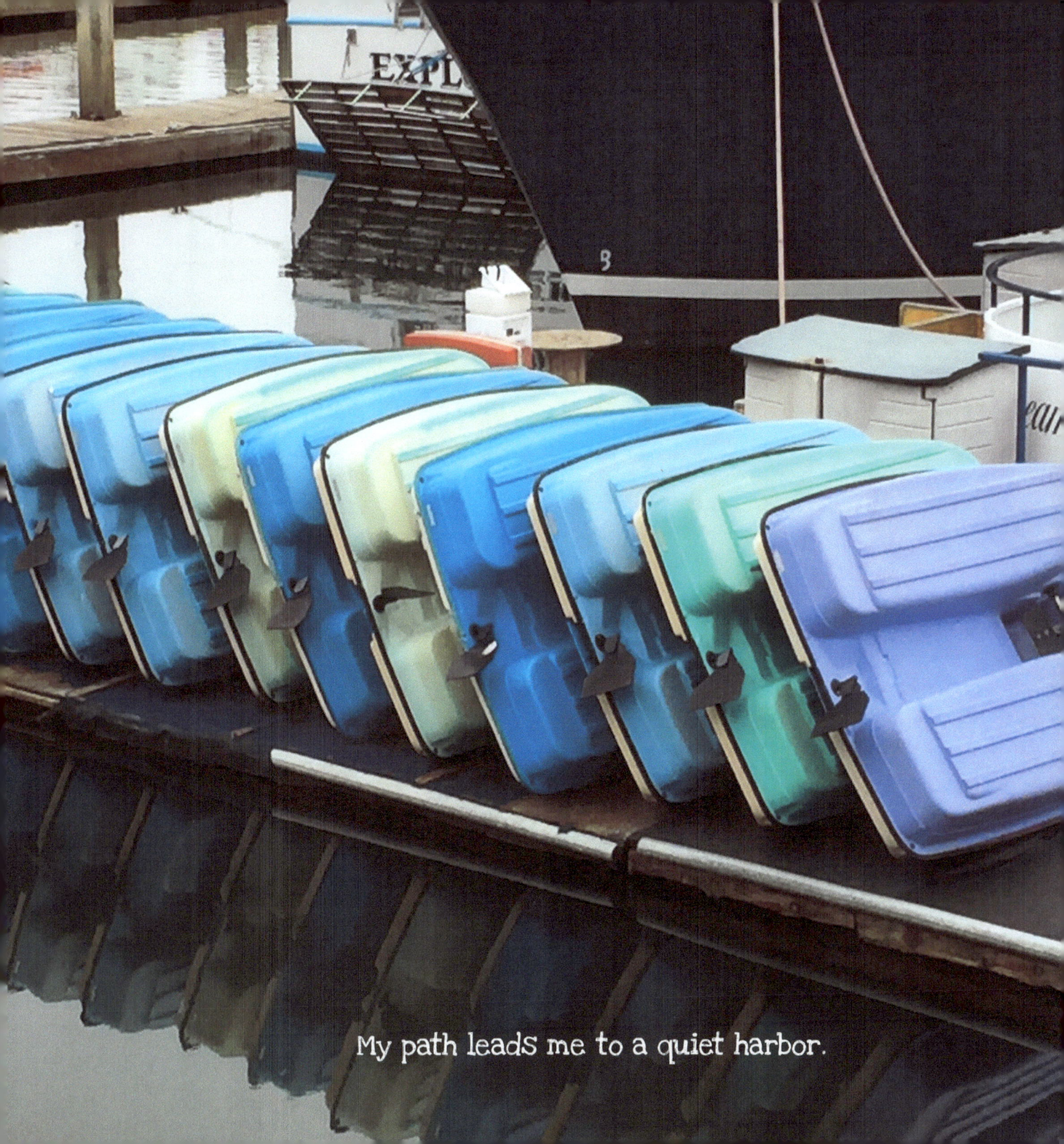
My path leads me to a quiet harbor.

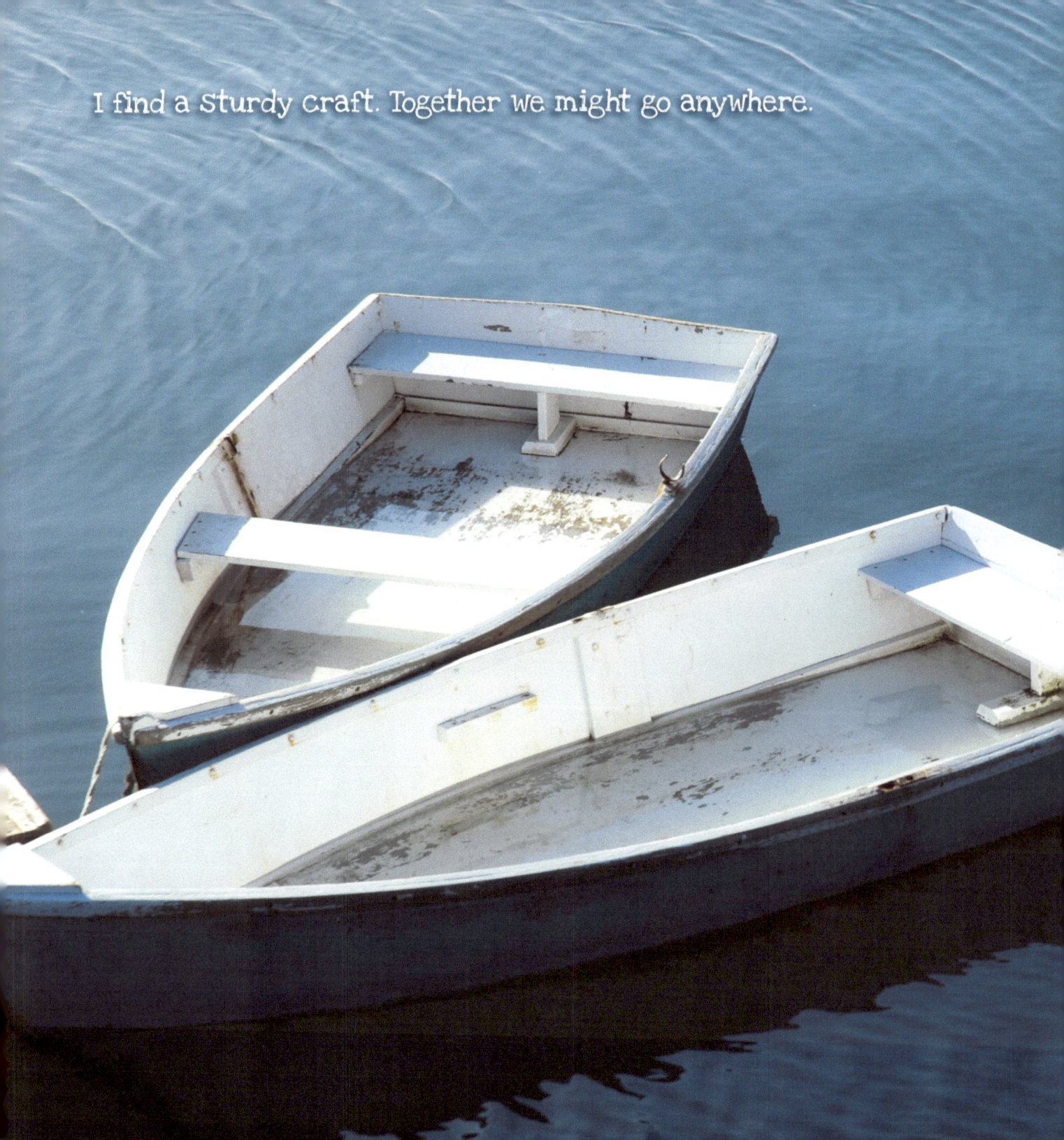

I find a sturdy craft. Together we might go anywhere.

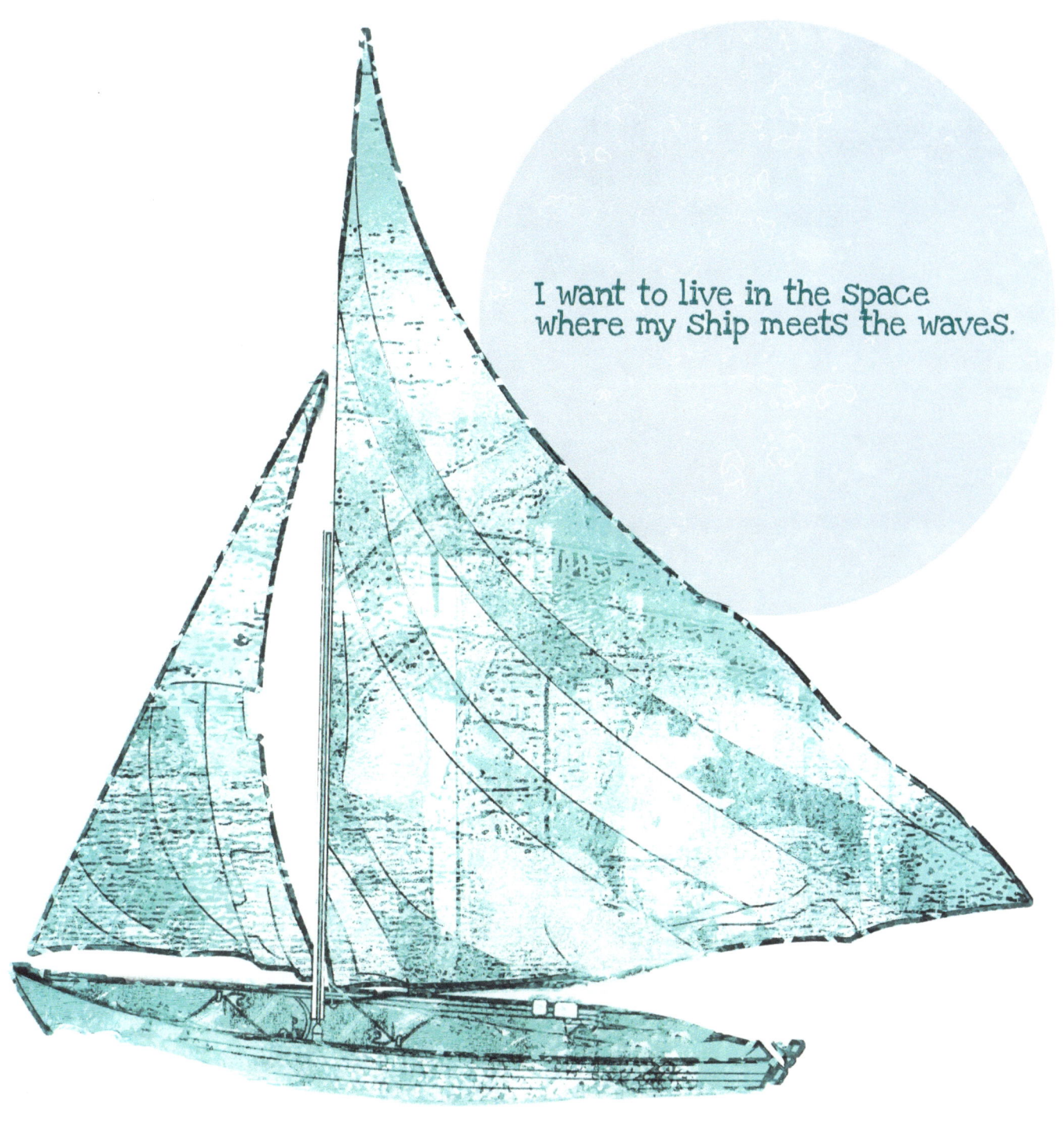

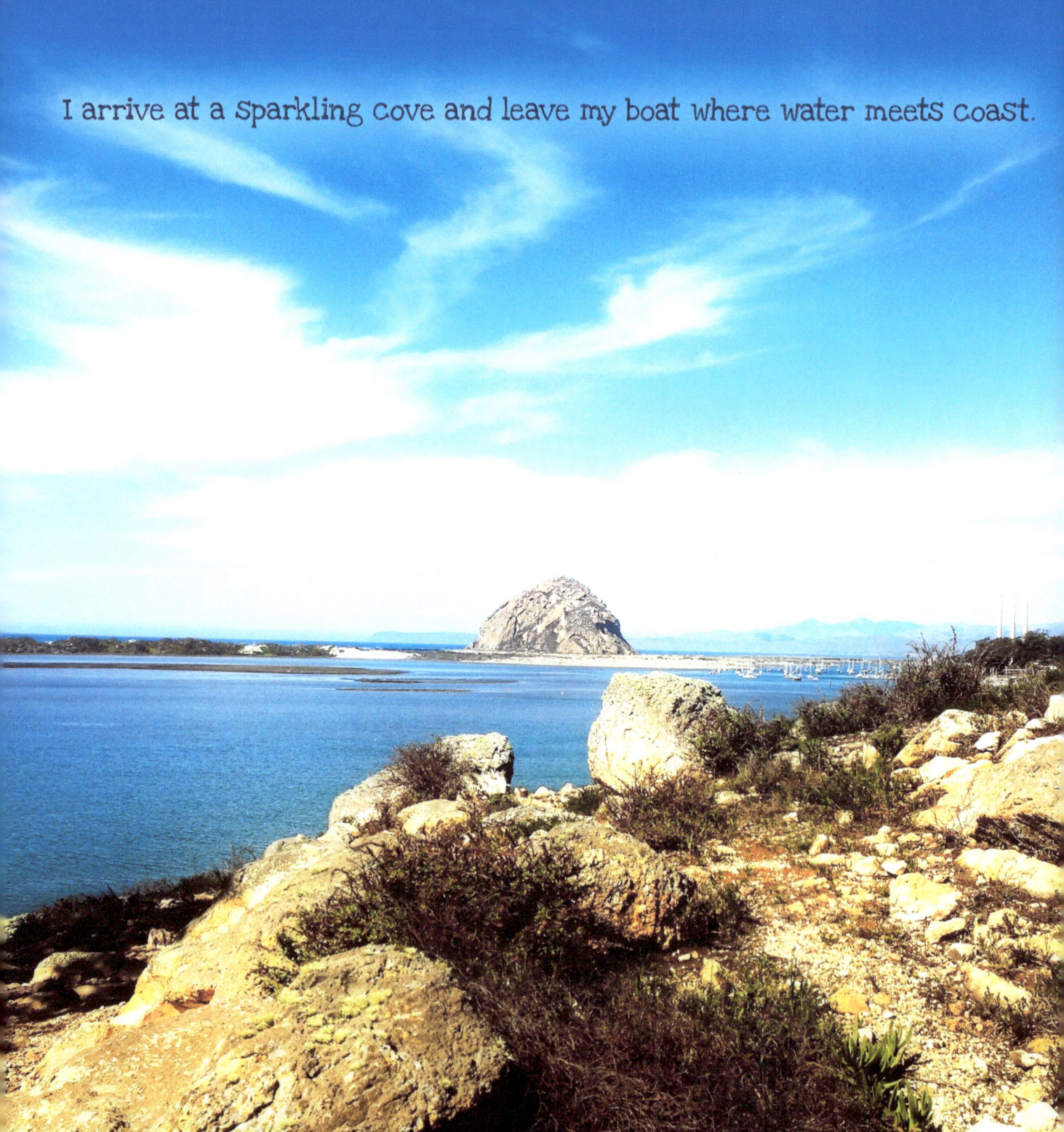

I arrive at a sparkling cove and leave my boat where water meets coast.

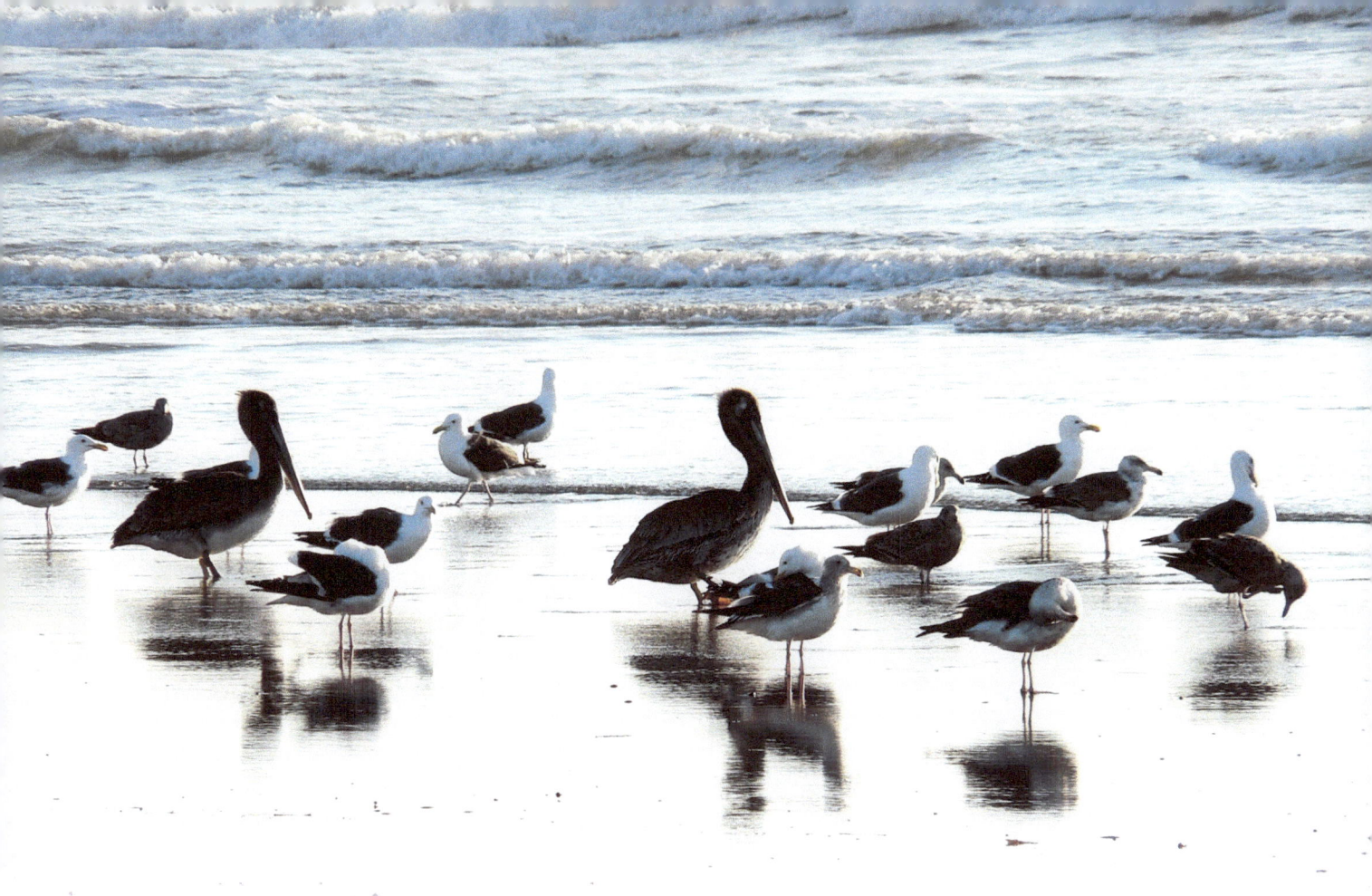

I step on shore to explore.

My voice slips in with the cries of gulls
and we sing of shared dreams.

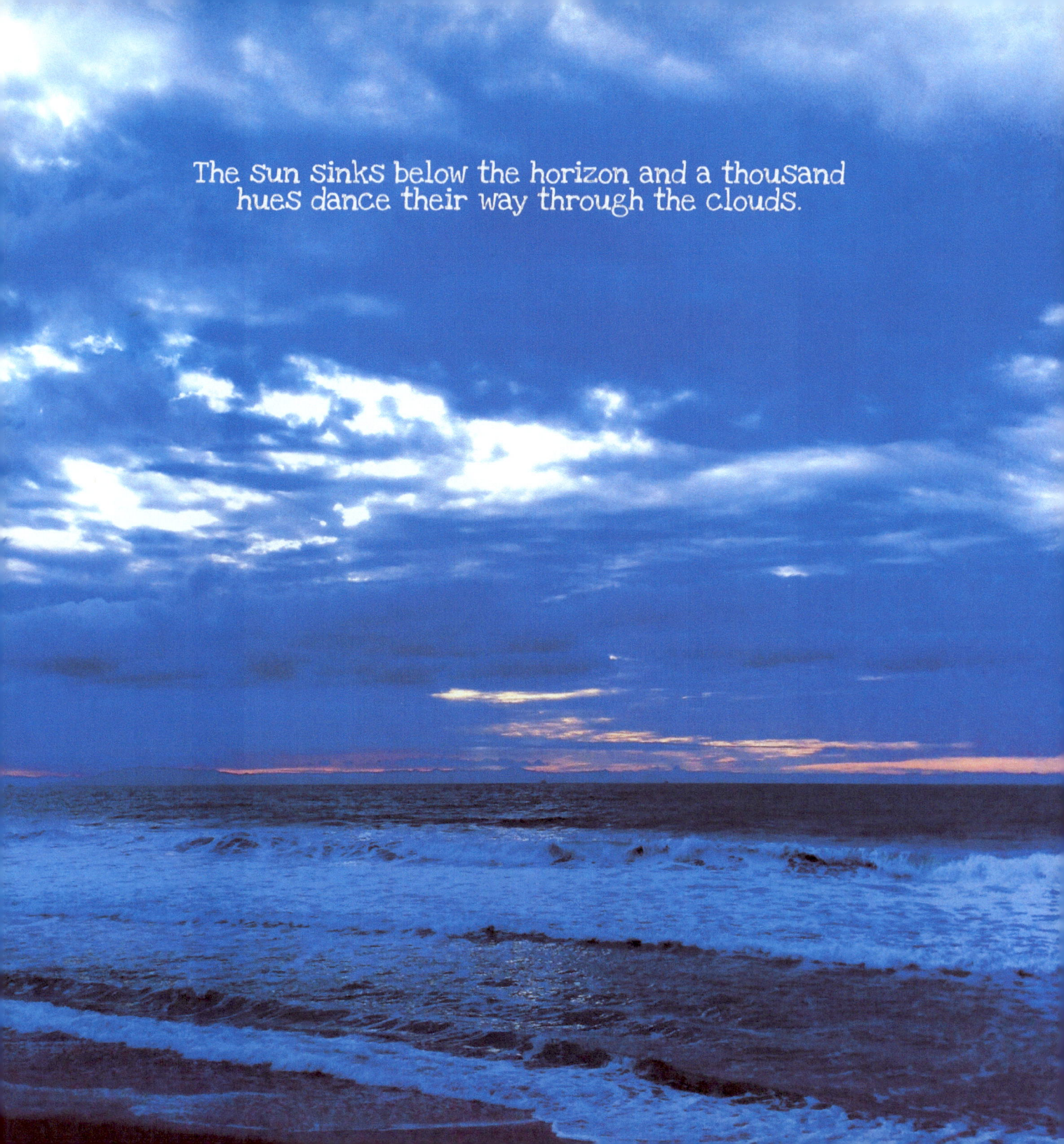
The sun sinks below the horizon and a thousand hues dance their way through the clouds.

The air fills with clouds of crystal and I travel through the night enfolded in a cloak of mist and fog.

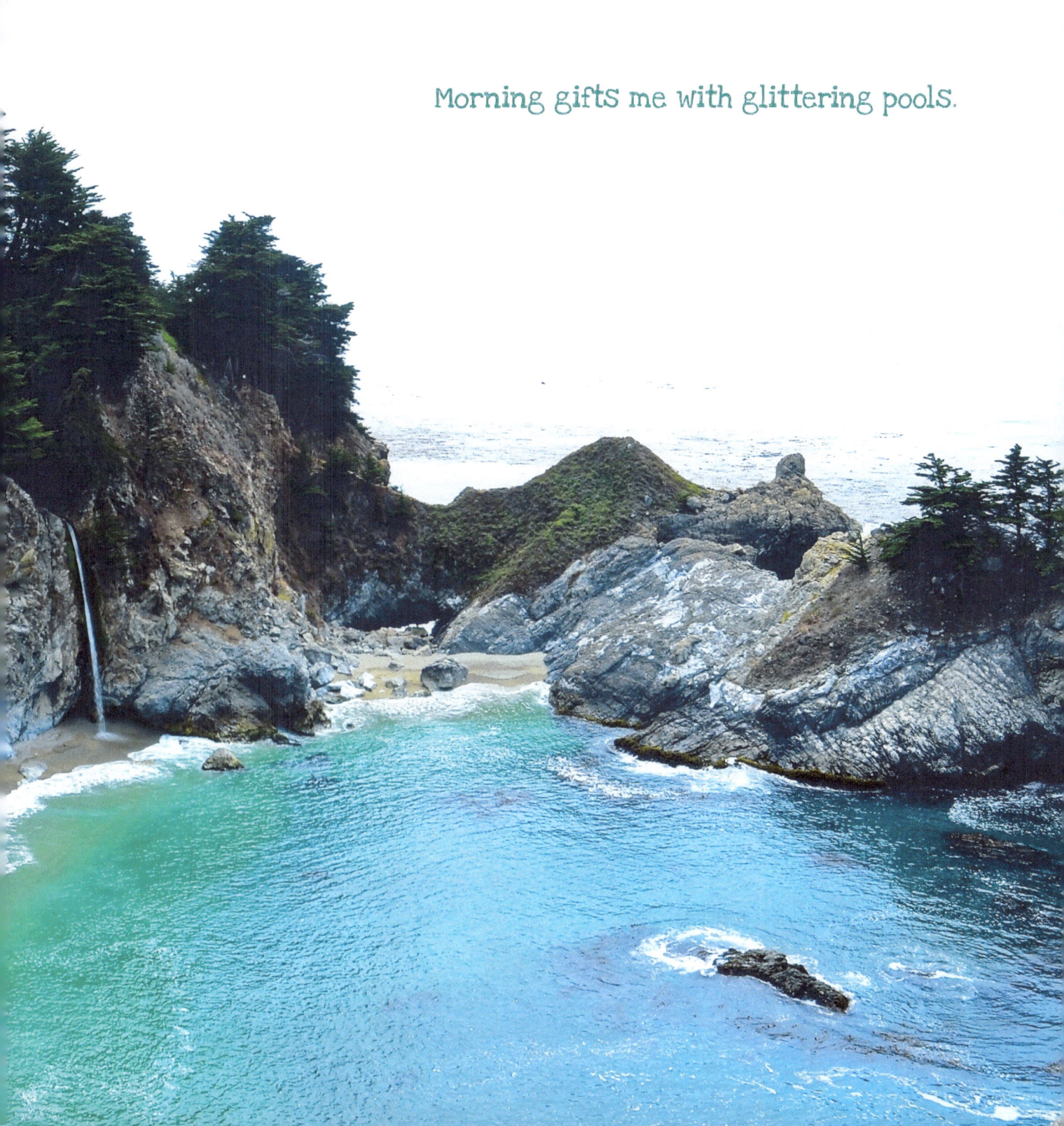

Morning gifts me with glittering pools.

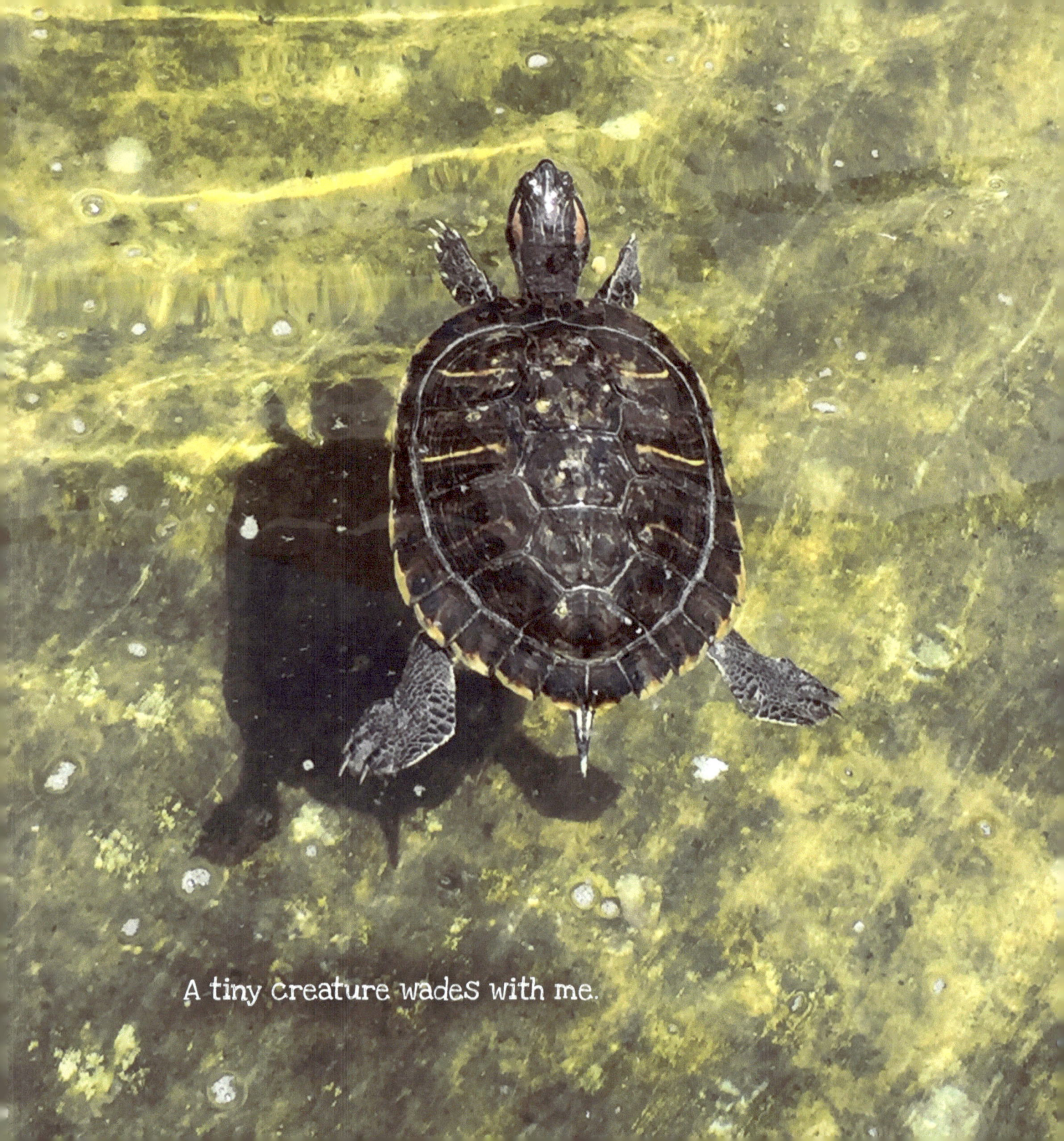
A tiny creature wades with me.

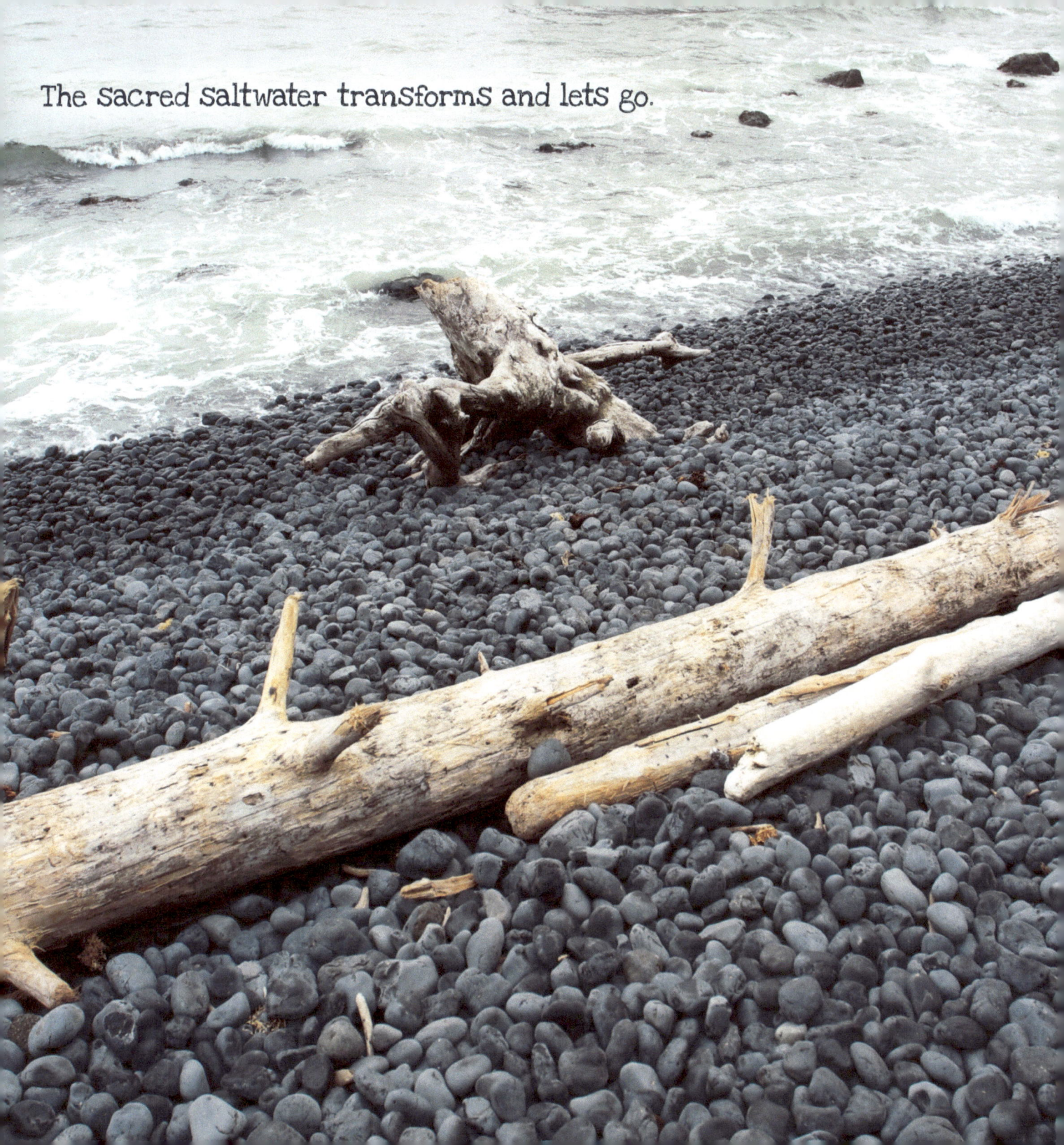

The sacred saltwater transforms and lets go.

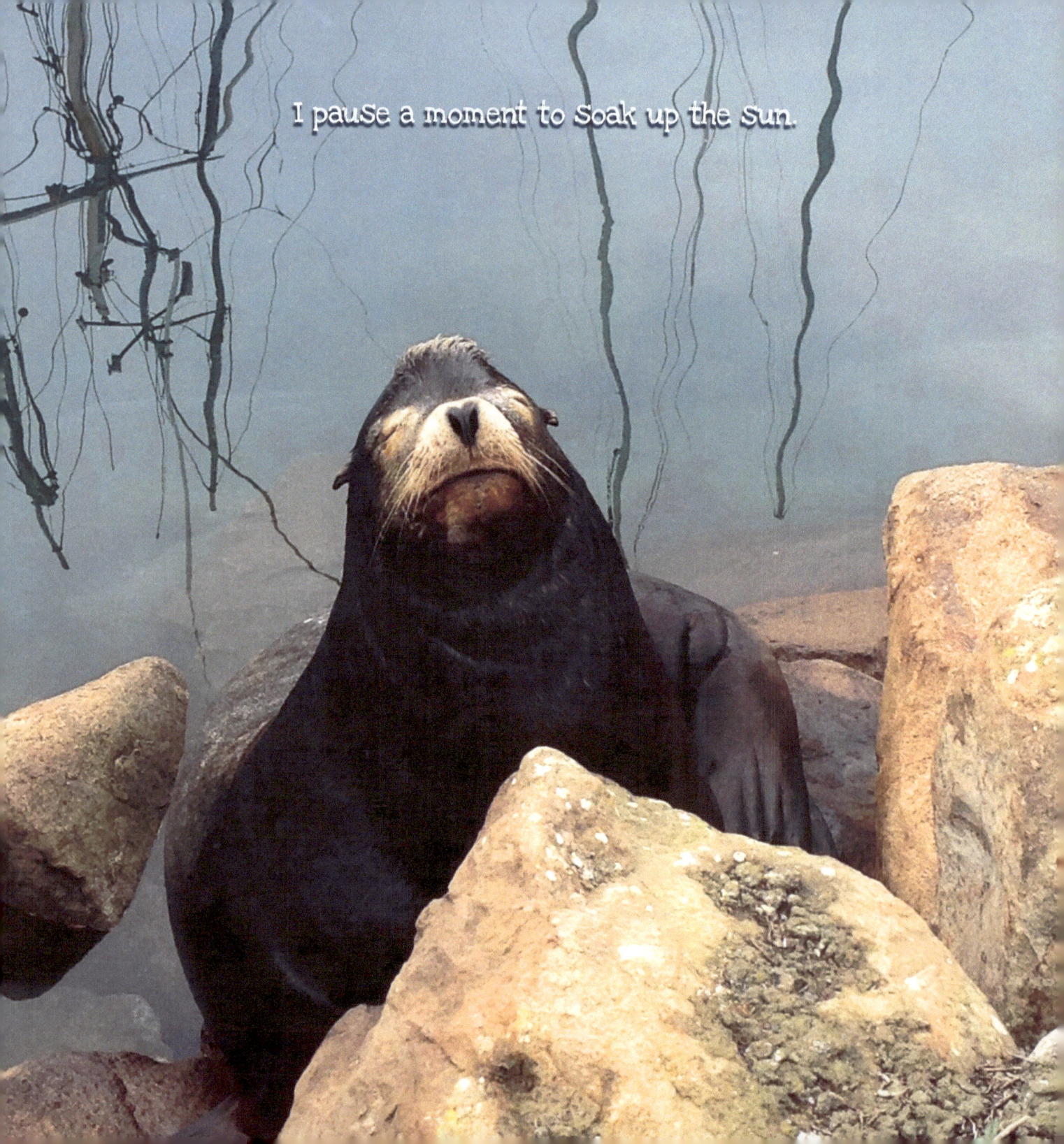

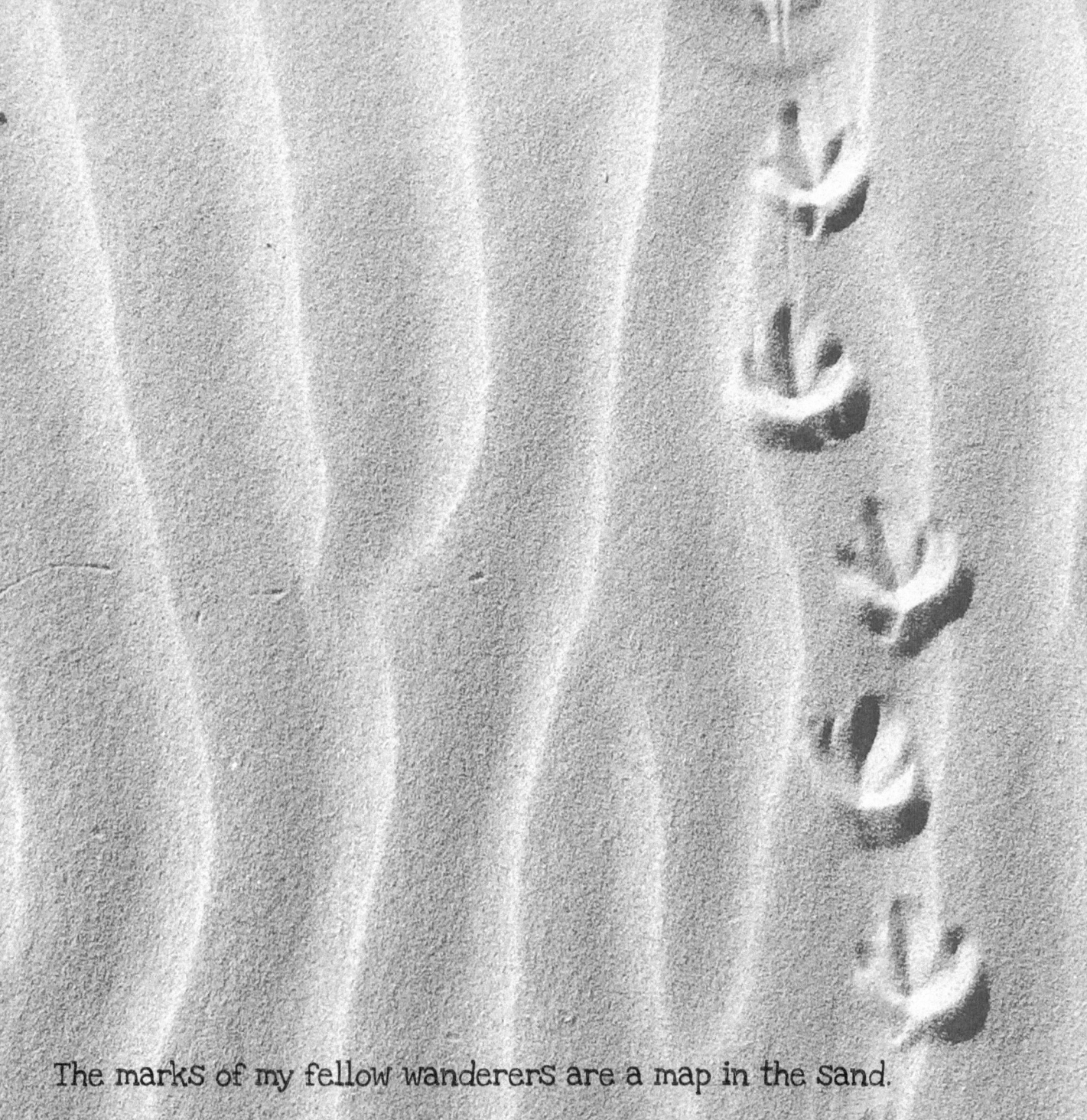

The marks of my fellow wanderers are a map in the sand.

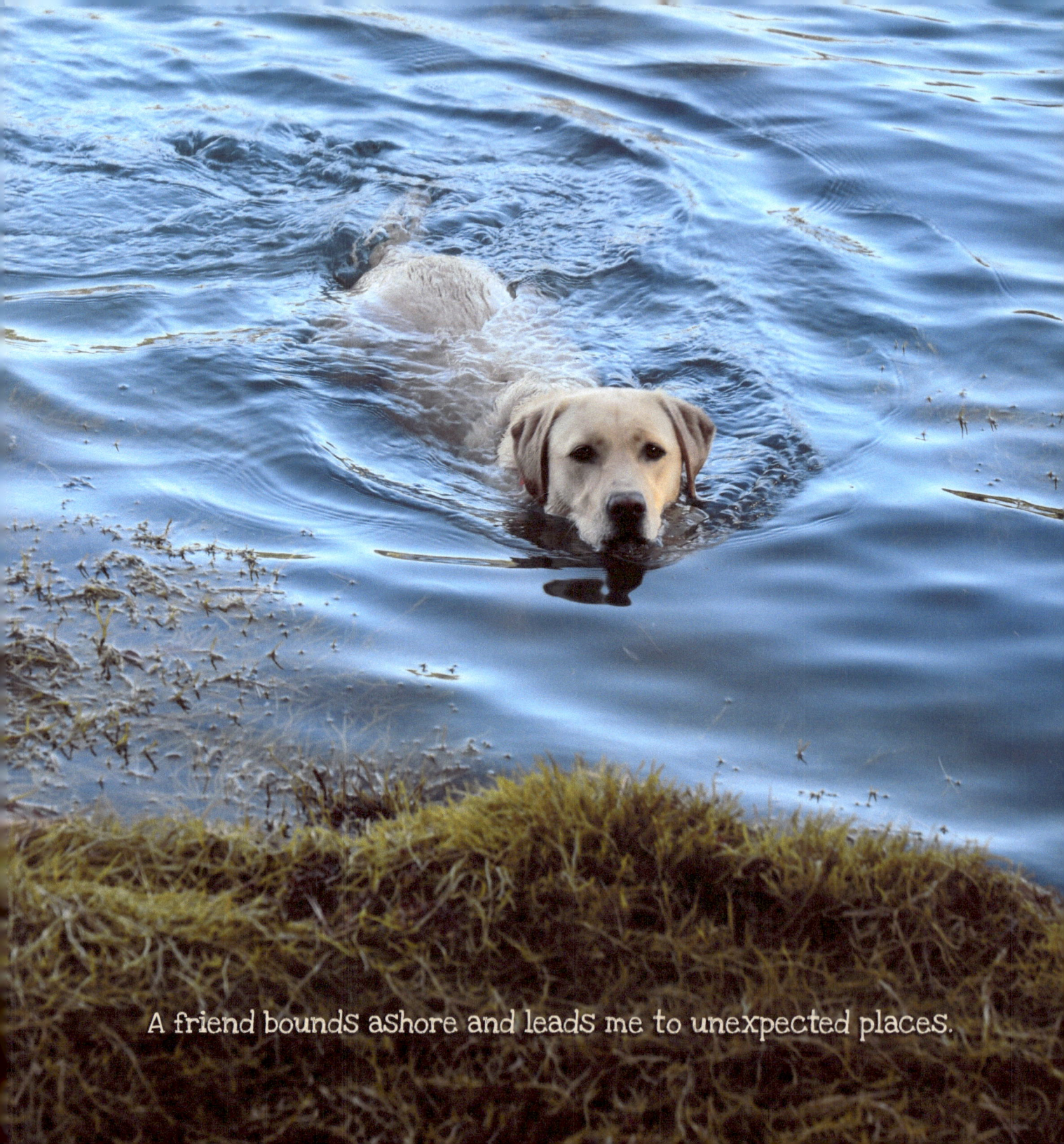
A friend bounds ashore and leads me to unexpected places.

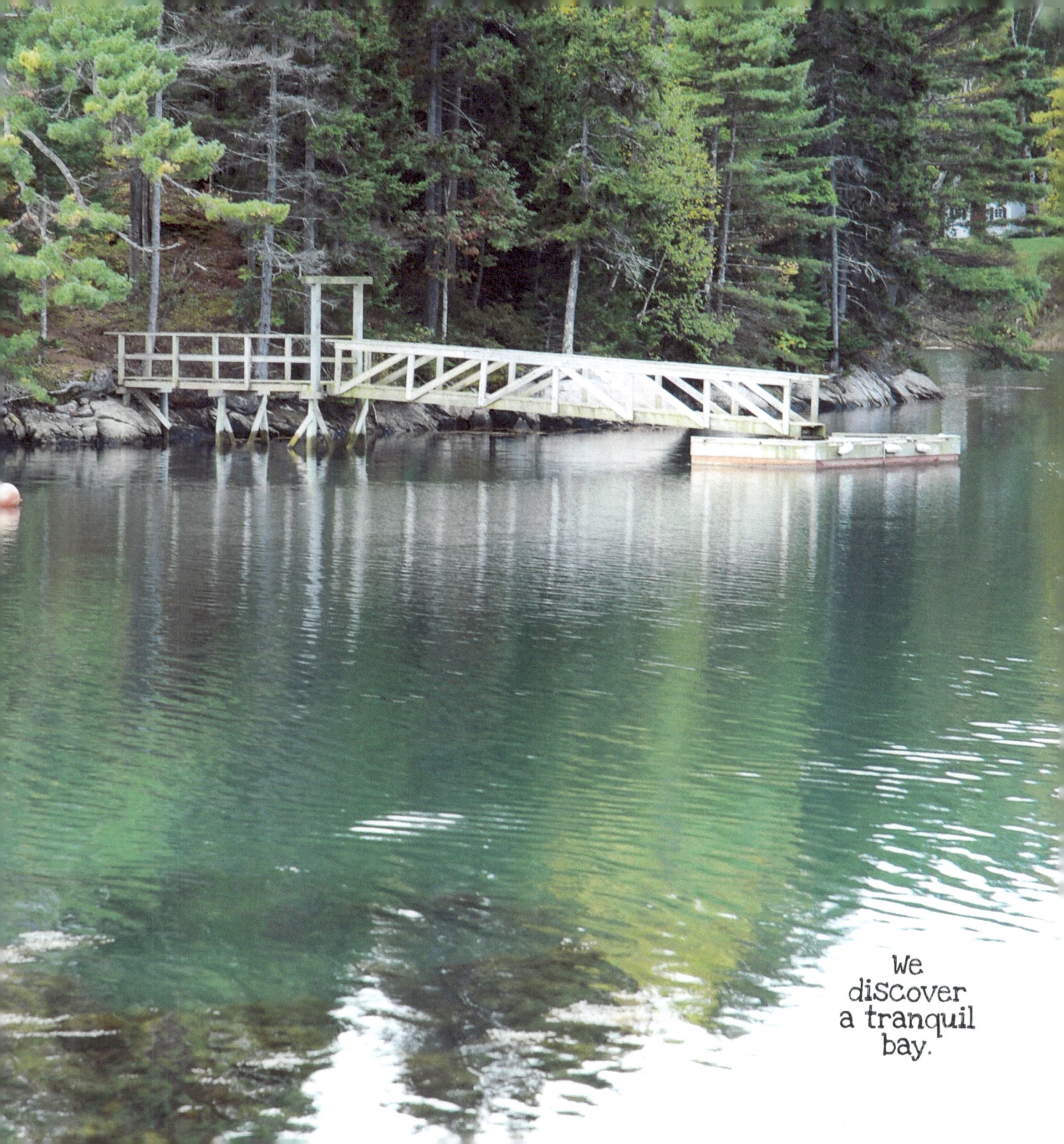

we discover a tranquil bay.

The sea is my anchor.

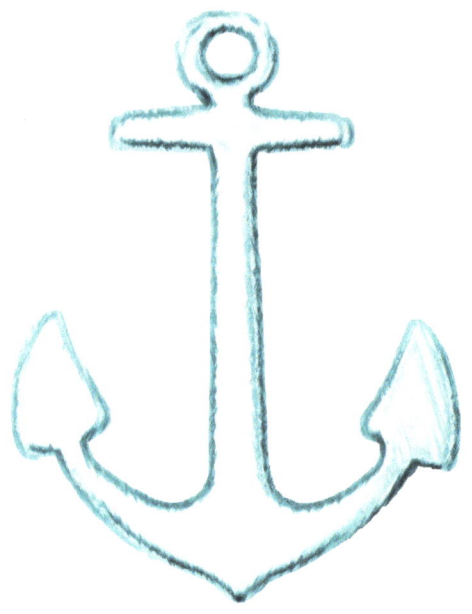

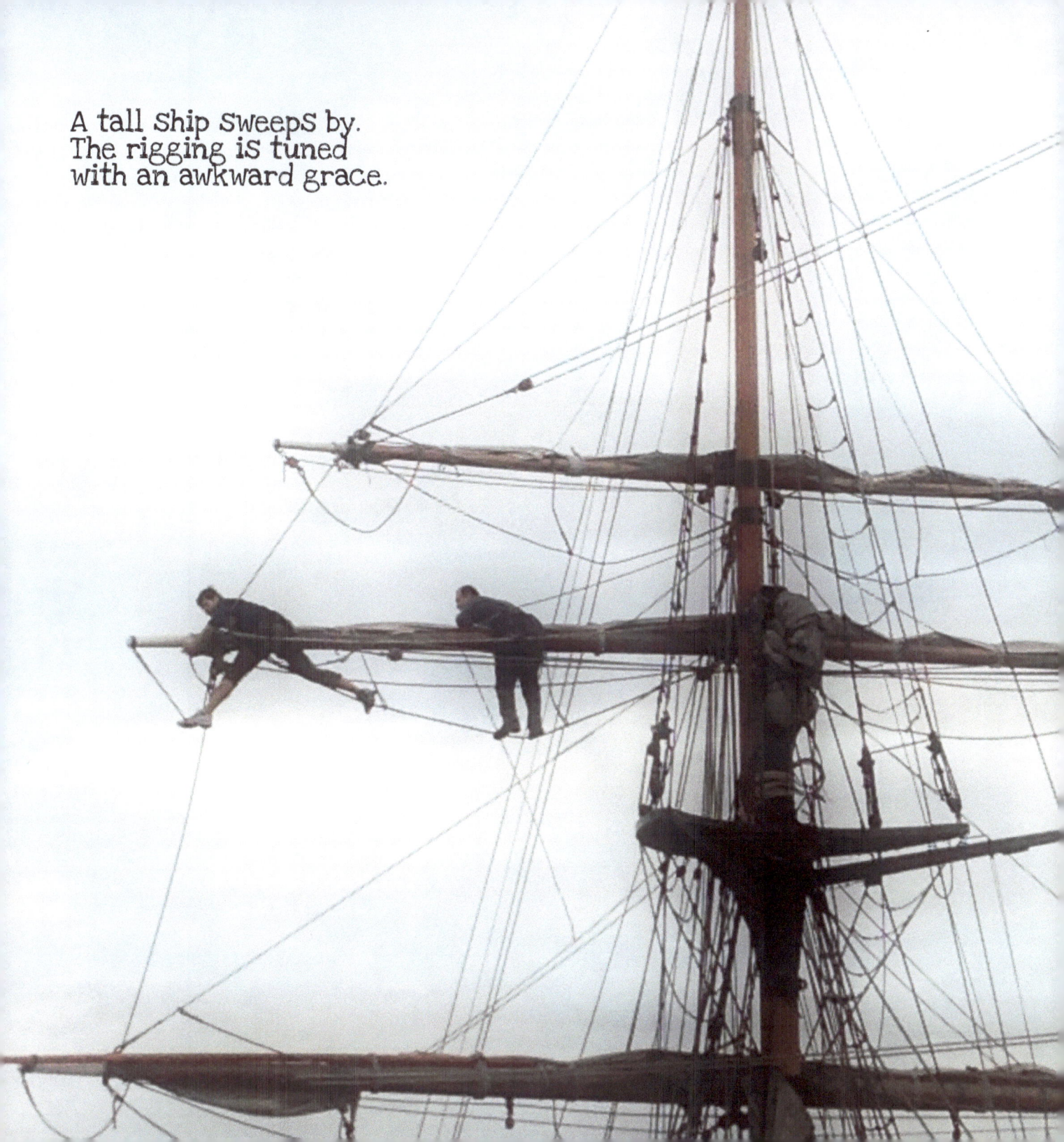

A tall ship sweeps by.
The rigging is tuned
with an awkward grace.

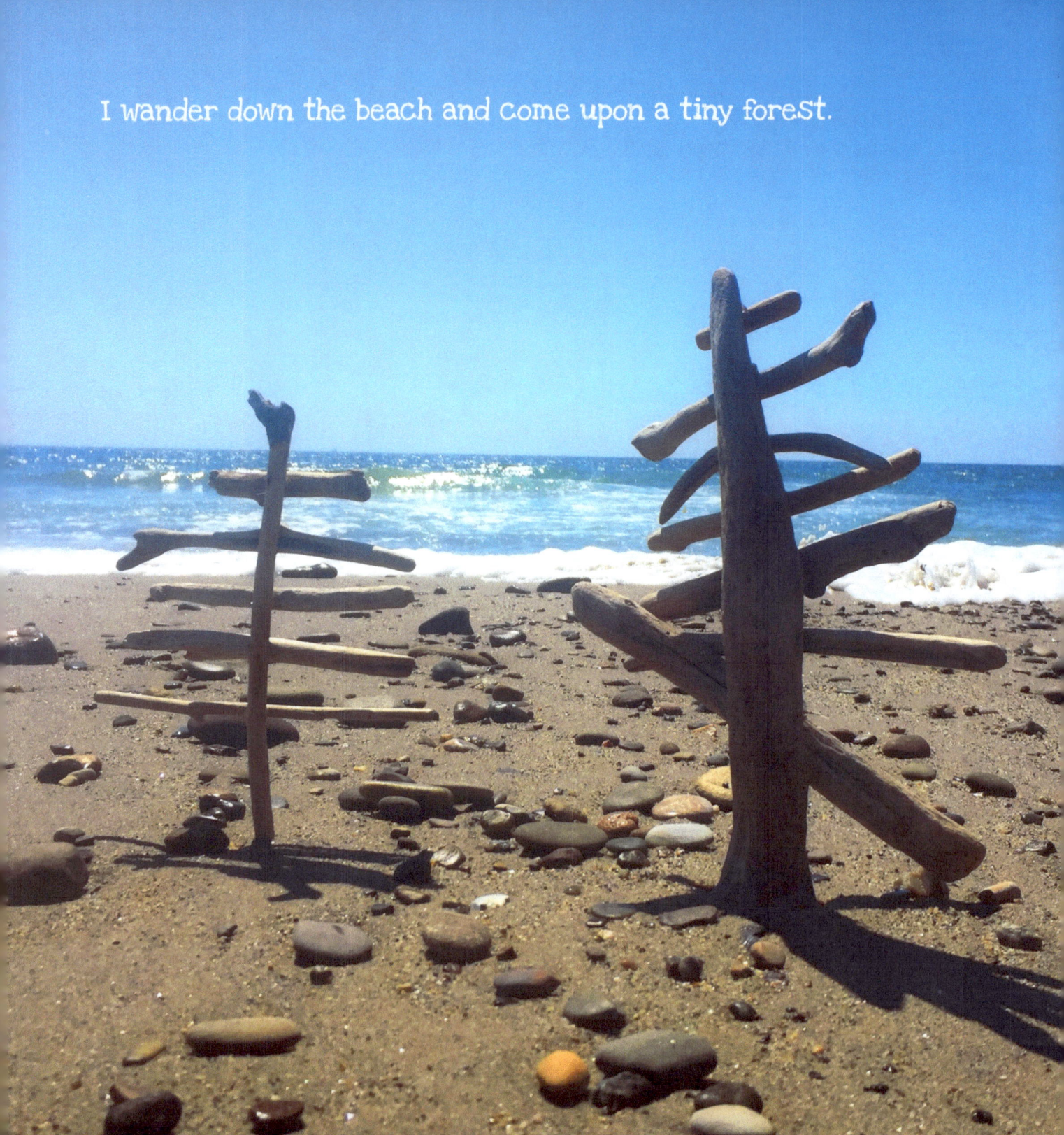
I wander down the beach and come upon a tiny forest.

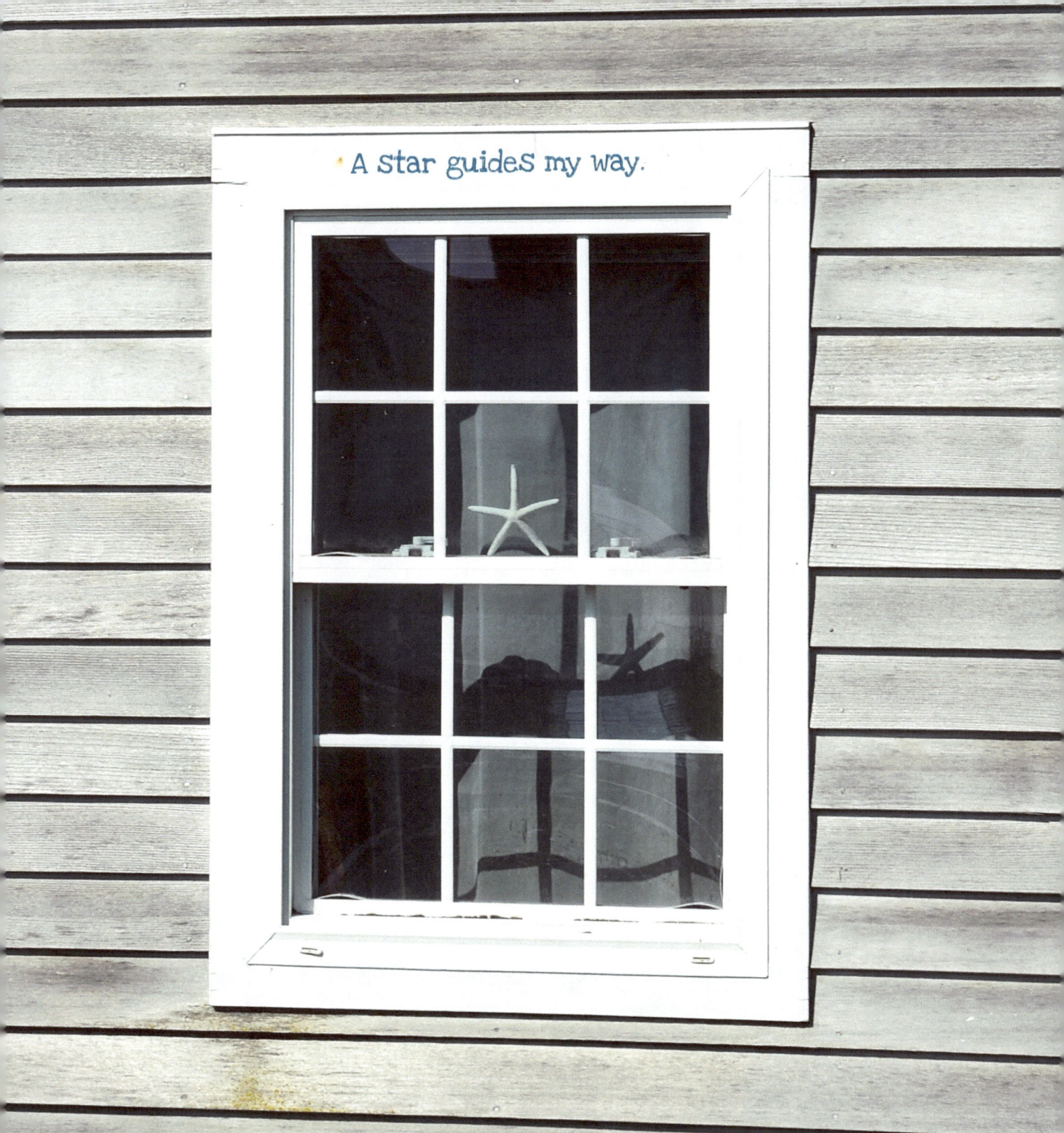

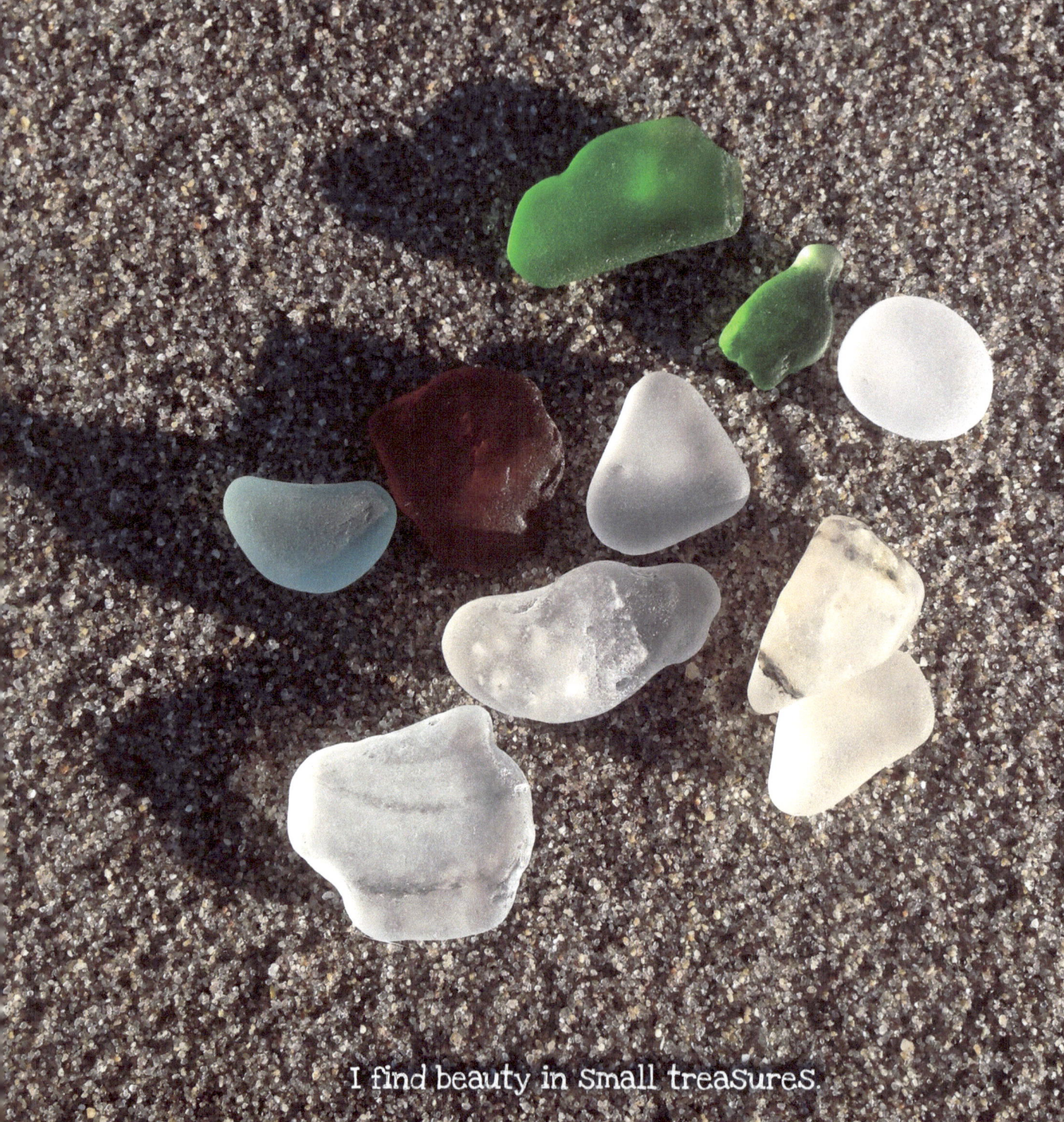
I find beauty in small treasures.

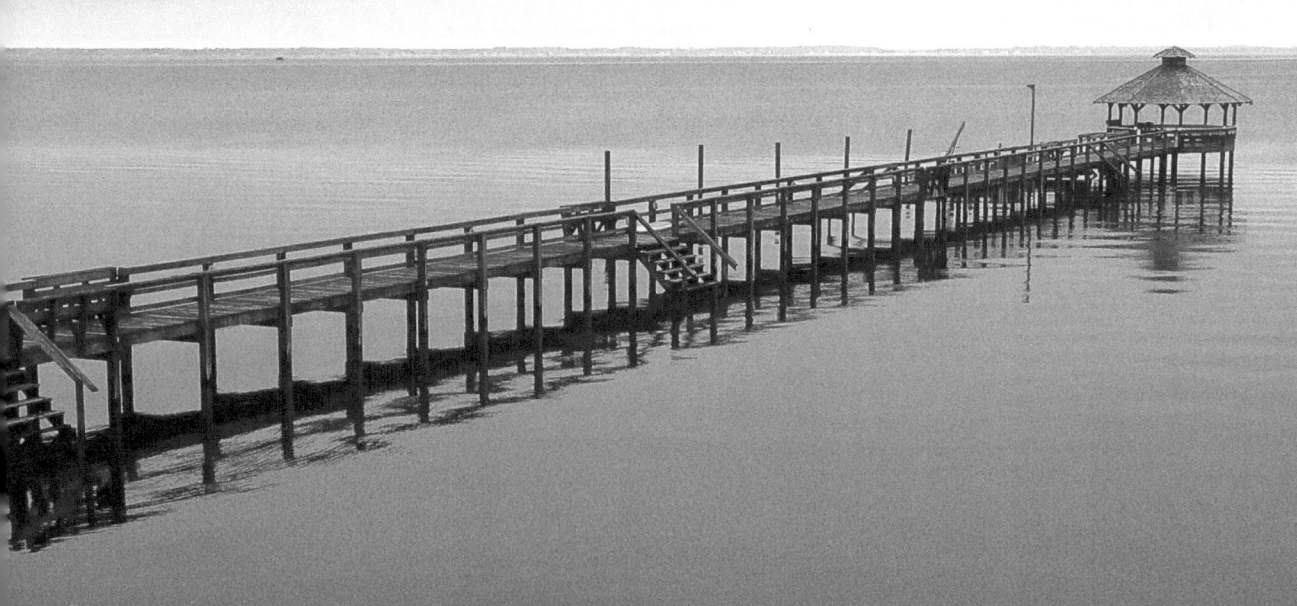

The Sea is my mirror.

My skin is built of grains of sand.
My blood is saltwater.
My voice is the wind.

I dream of the sea.

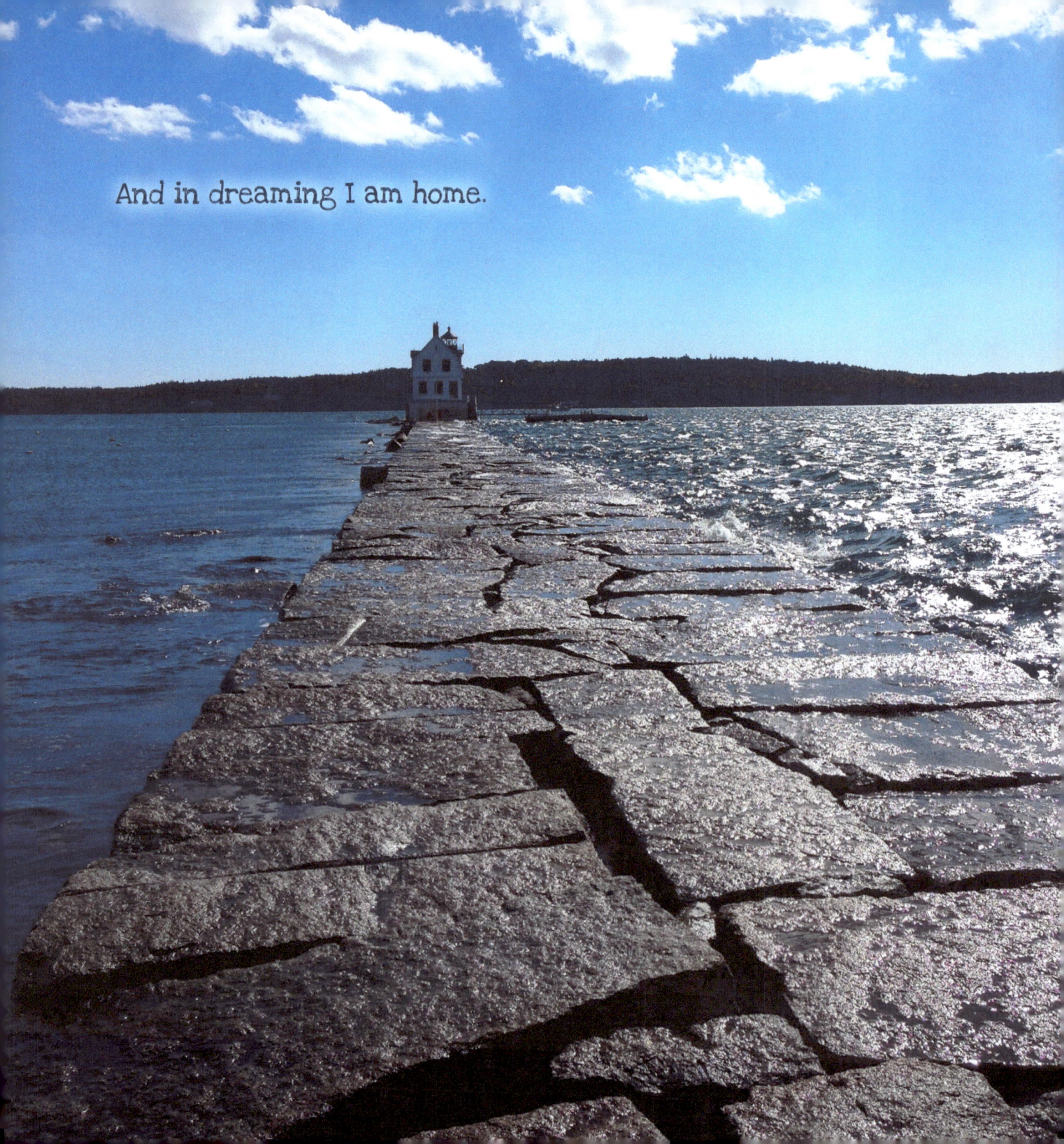
And in dreaming I am home.

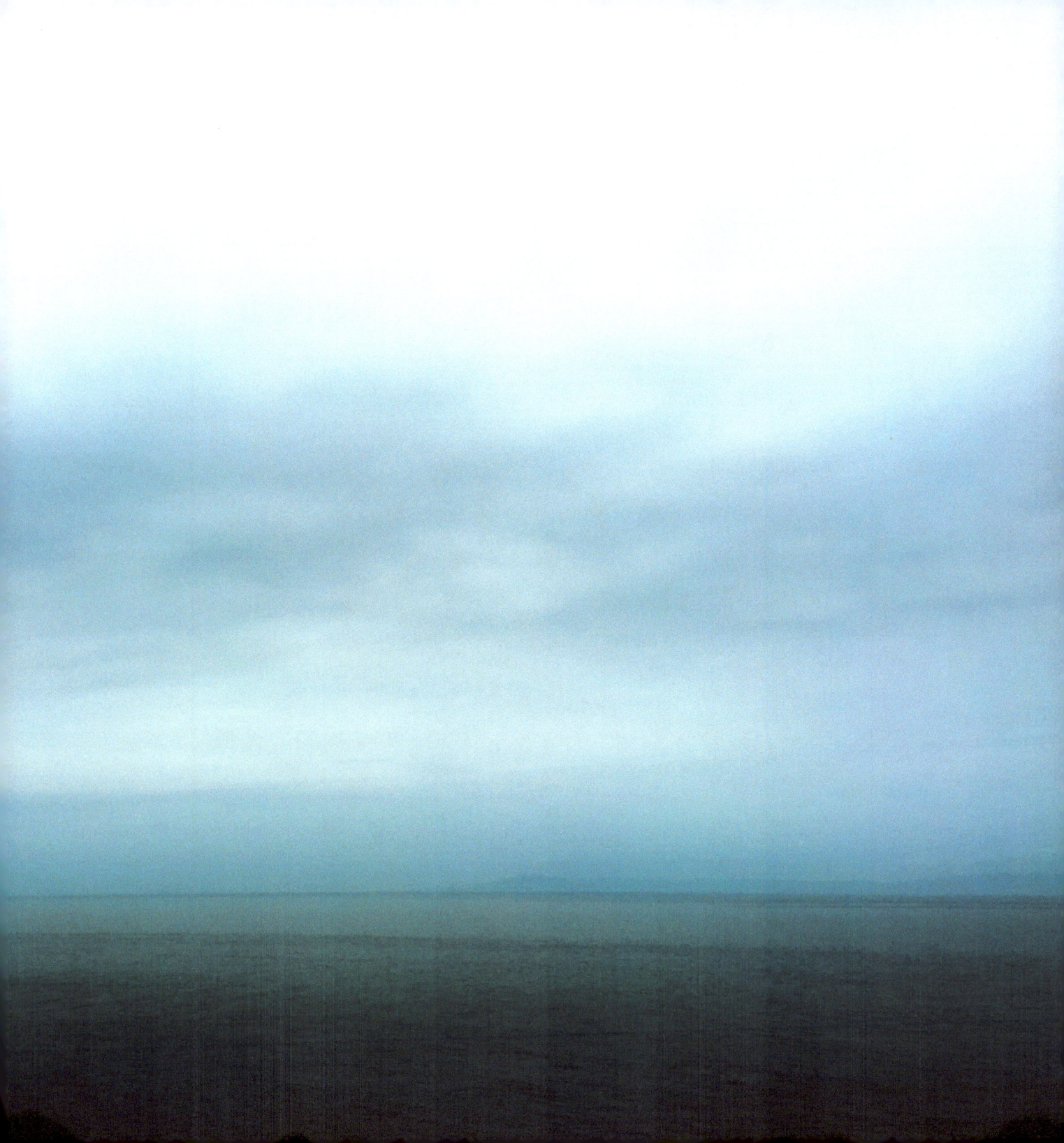

Miki Klocke is a professional photographer and fused glass artist. Her images and art can be found at mikiklocke.com.

Follow Miki at: MikiKlocke

After attending the Rhode Island School of Design and Art Center College, Mary Ogle emerged with a solid grounding in the art of oil painting. Not satisfied with the limitations of brush and canvas, she stumbled upon the world of computer graphics and never looked back. To see more of Mary's work visit maryogle.com.

Follow Mary at: evisionarts

www.ingramcontent.com/pod-product-compliance
Lightning Source LLC
Chambersburg PA
CBHW050357180526
45159CB00005B/2060